Crabbing

Young Palmetto Books

Young Palmetto Books
Kim Shealy Jeffcoat, Series Editor

Crabbing

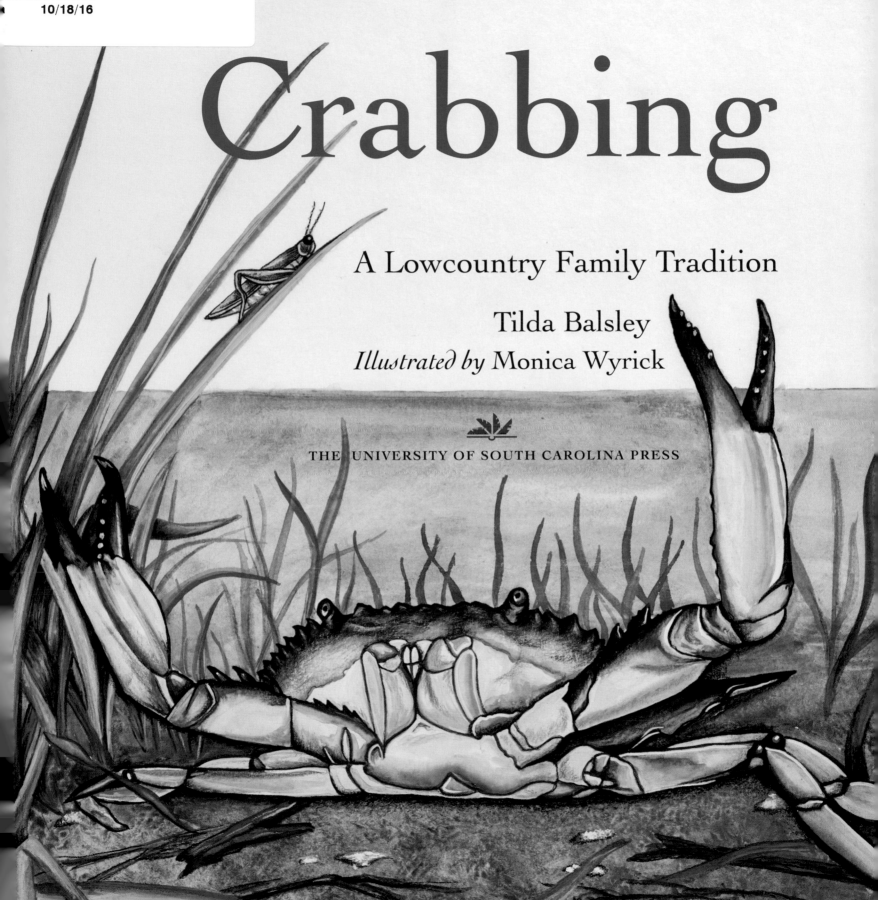

A Lowcountry Family Tradition

Tilda Balsley

Illustrated by Monica Wyrick

THE UNIVERSITY OF SOUTH CAROLINA PRESS

Text © 2016 Tilda Balsley
Illustrations © 2016 Monica Wyrick

Published by the University of South Carolina Press
Columbia, South Carolina 29208

www.sc.edu/uscpress

Manufactured in China

25 24 23 22 21 20 19 18 17 16
10 9 8 7 6 5 4 3 2 1

Library of Congress Cataloging-in-Publication Data
can be found at http://catalog.loc.gov/.

ISBN: 978-1-61117-640-7 (hardcover)
ISBN: 978-1-61117-641-4 (ebook)

For those who learned from Pop

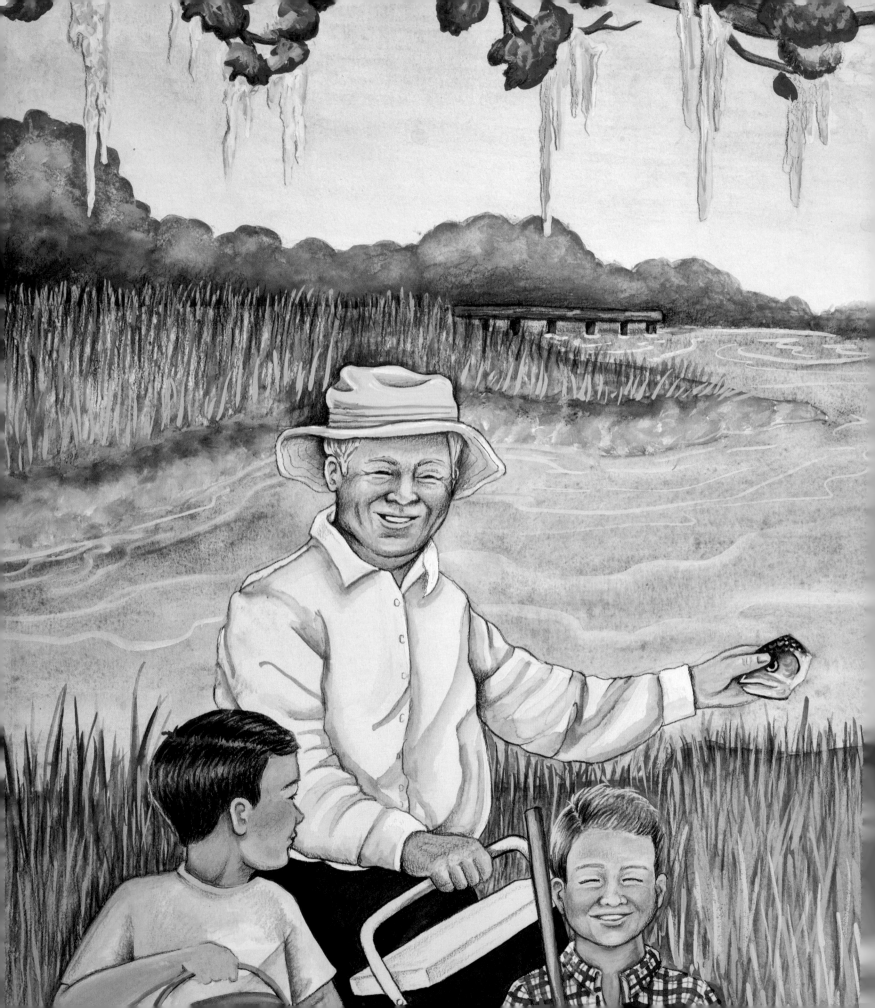

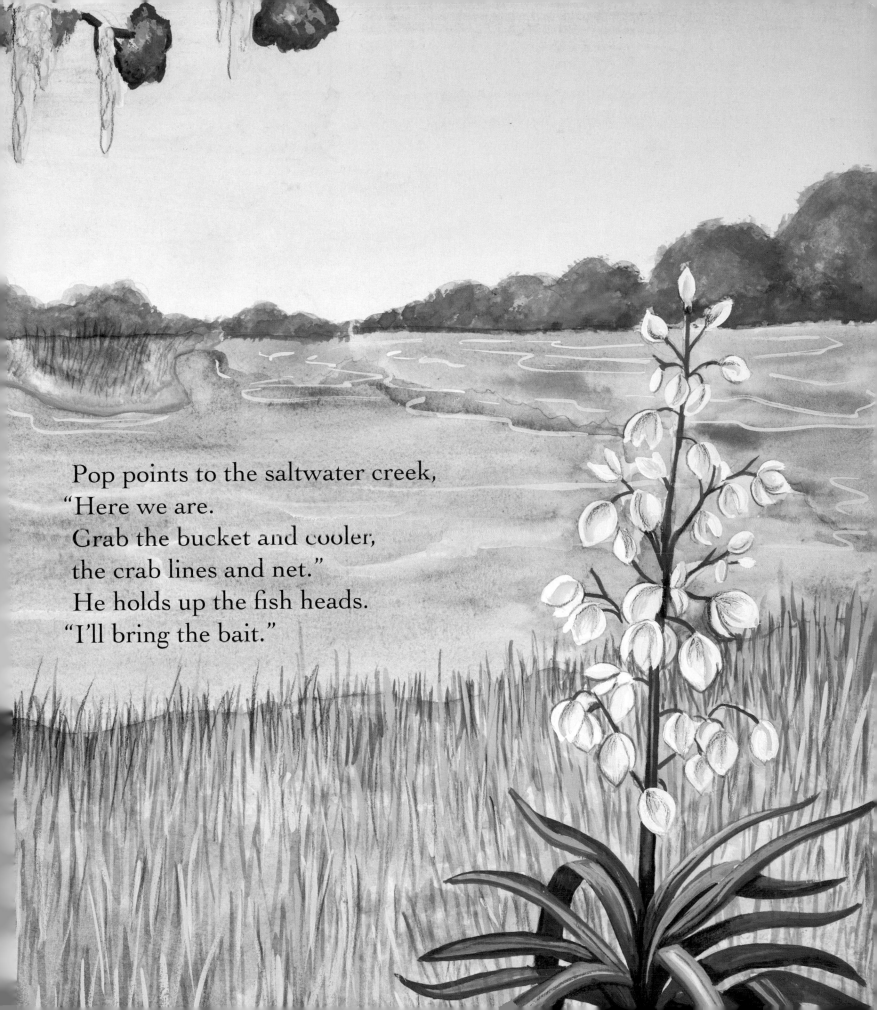

Pop points to the saltwater creek,
"Here we are.
Grab the bucket and cooler,
the crab lines and net."
He holds up the fish heads.
"I'll bring the bait."

Squish. Onto the mud bank,
 ready to crab.
Pop hands me a fish head,
 slimy and smelly.
 Then some string, and
 a weight.

But tying's not easy.
"Give it here," says Ben.
"Now, sling it."
Splash!
Into dark water near
 shady sea grass.

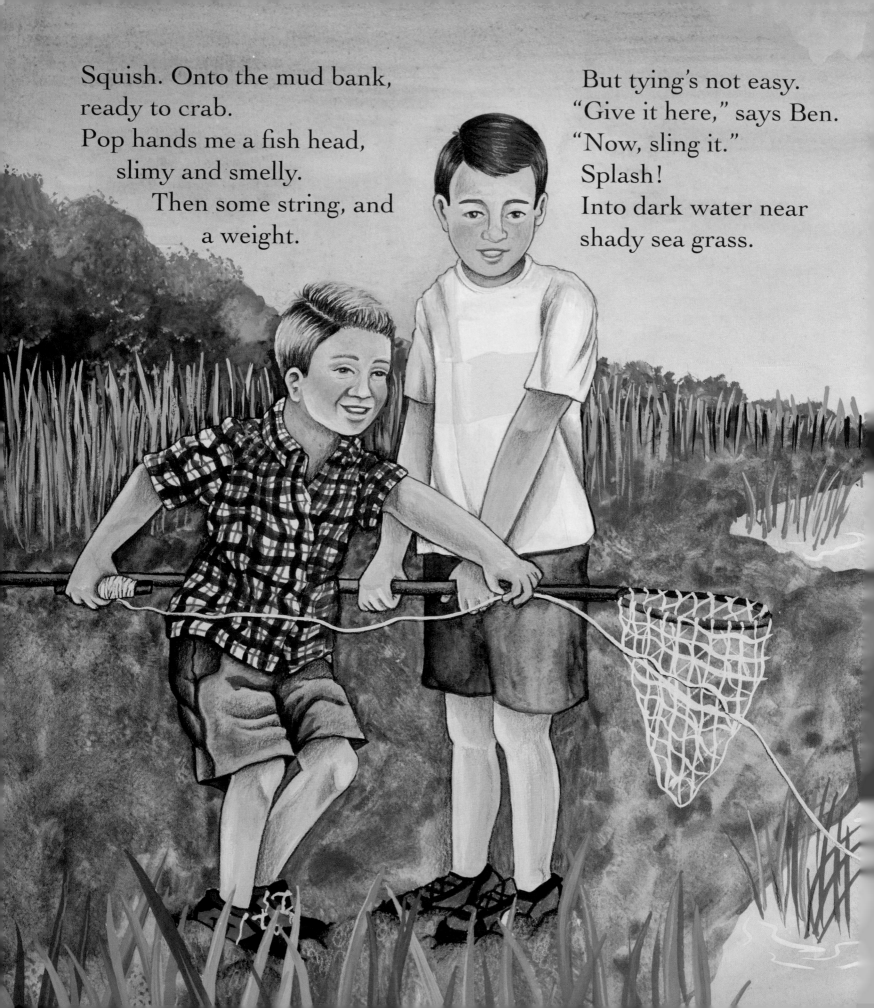

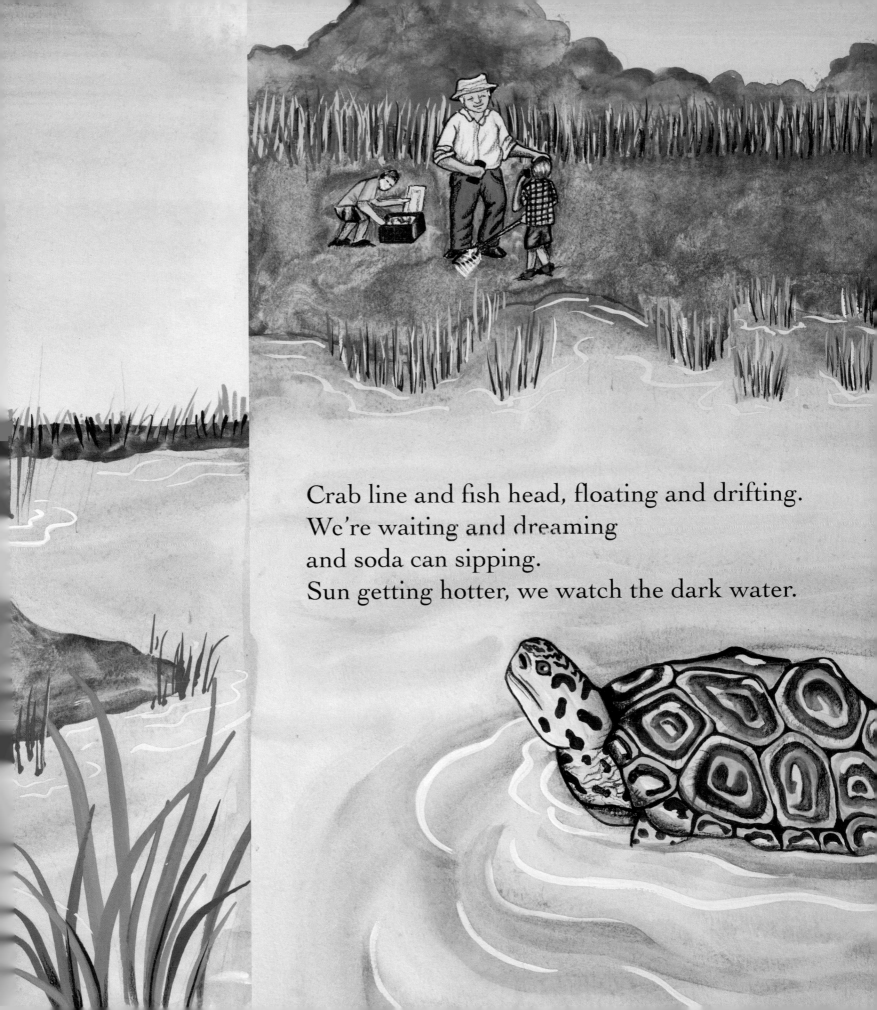

Crab line and fish head, floating and drifting.
We're waiting and dreaming
and soda can sipping.
Sun getting hotter, we watch the dark water.

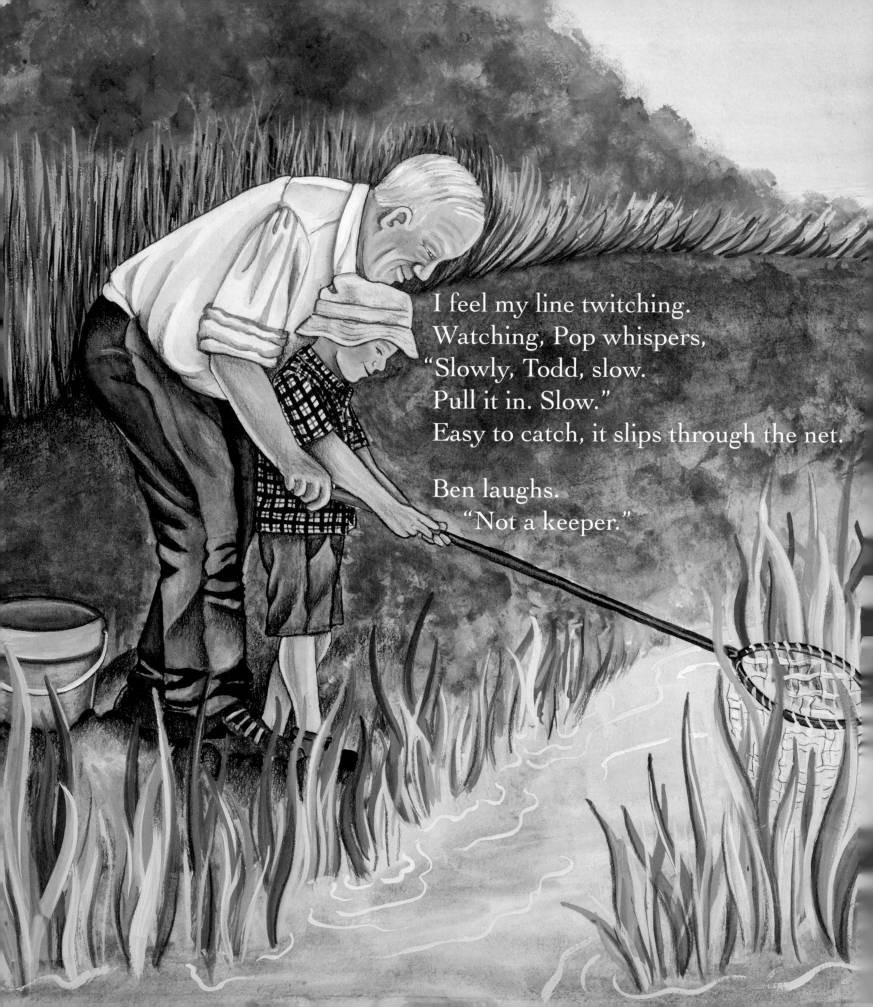

I feel my line twitching.
Watching, Pop whispers,
"Slowly, Todd, slow.
Pull it in. Slow."
Easy to catch, it slips through the net.

Ben laughs.
 "Not a keeper."

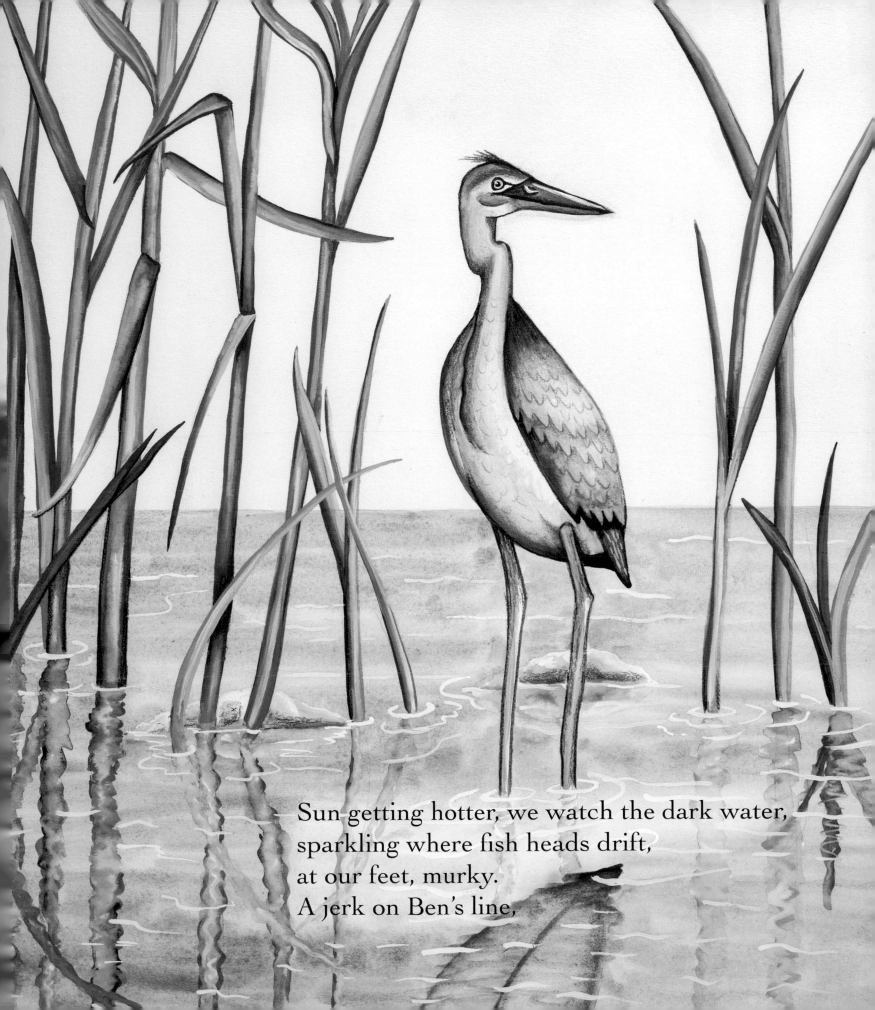

Sun getting hotter, we watch the dark water,
sparkling where fish heads drift,
at our feet, murky.
A jerk on Ben's line,

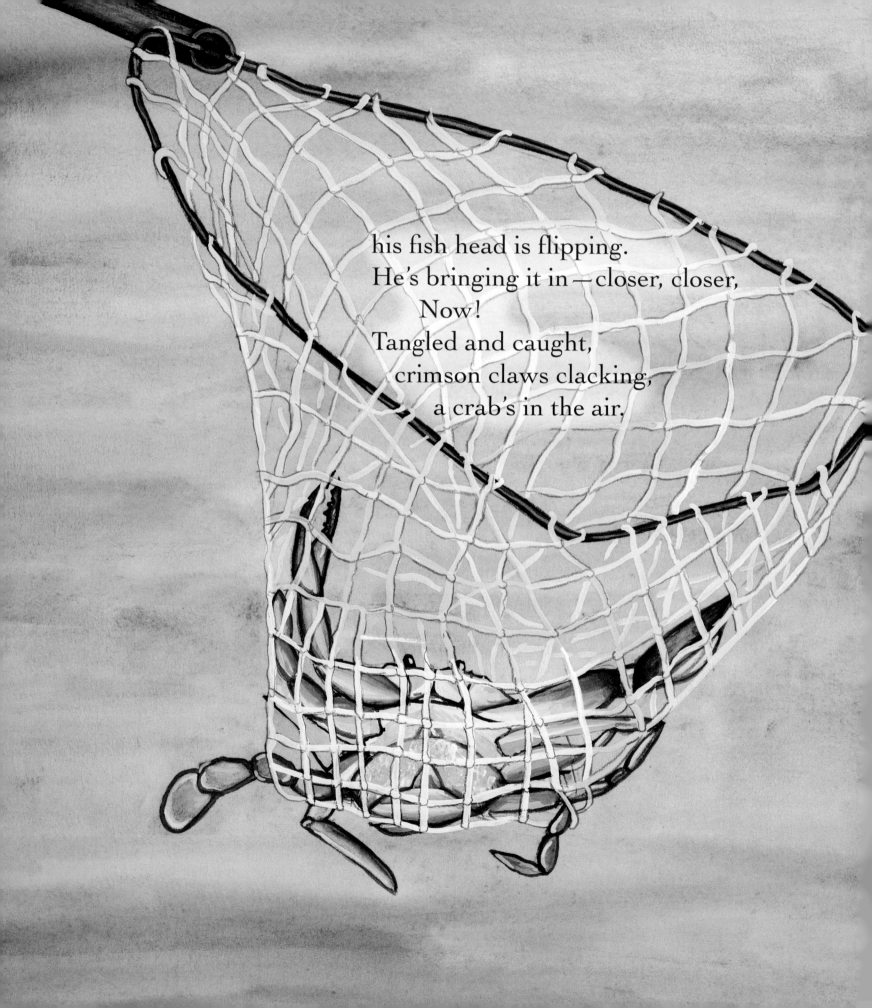

his fish head is flipping.
He's bringing it in — closer, closer,
Now!
Tangled and caught,
crimson claws clacking,
a crab's in the air.

Pop points to her shell,
"She's got eggs—we won't keep her."
He throws her out deeper.

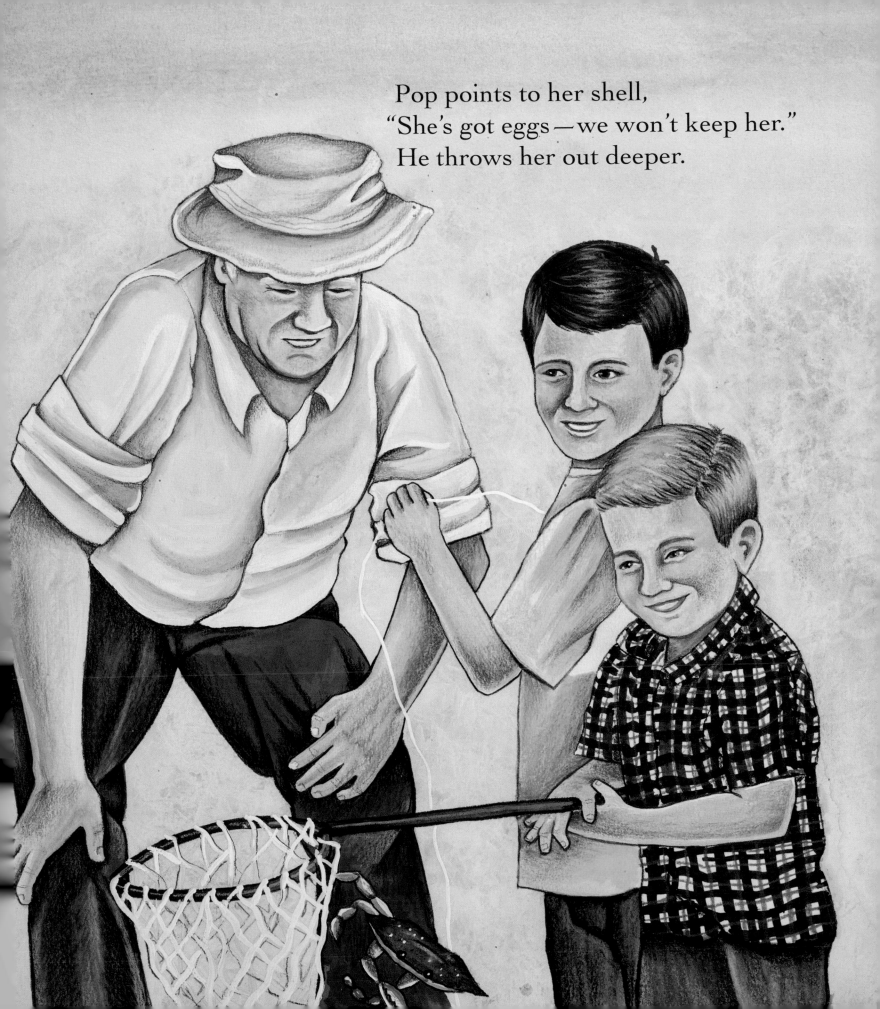

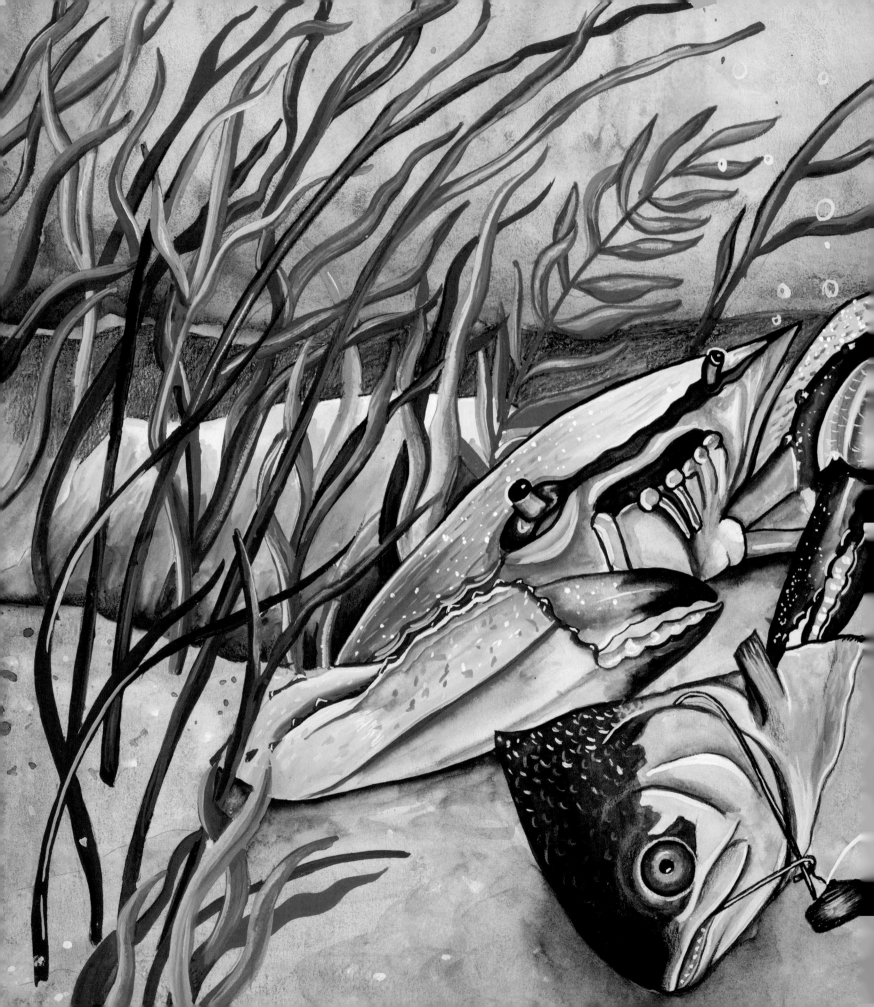

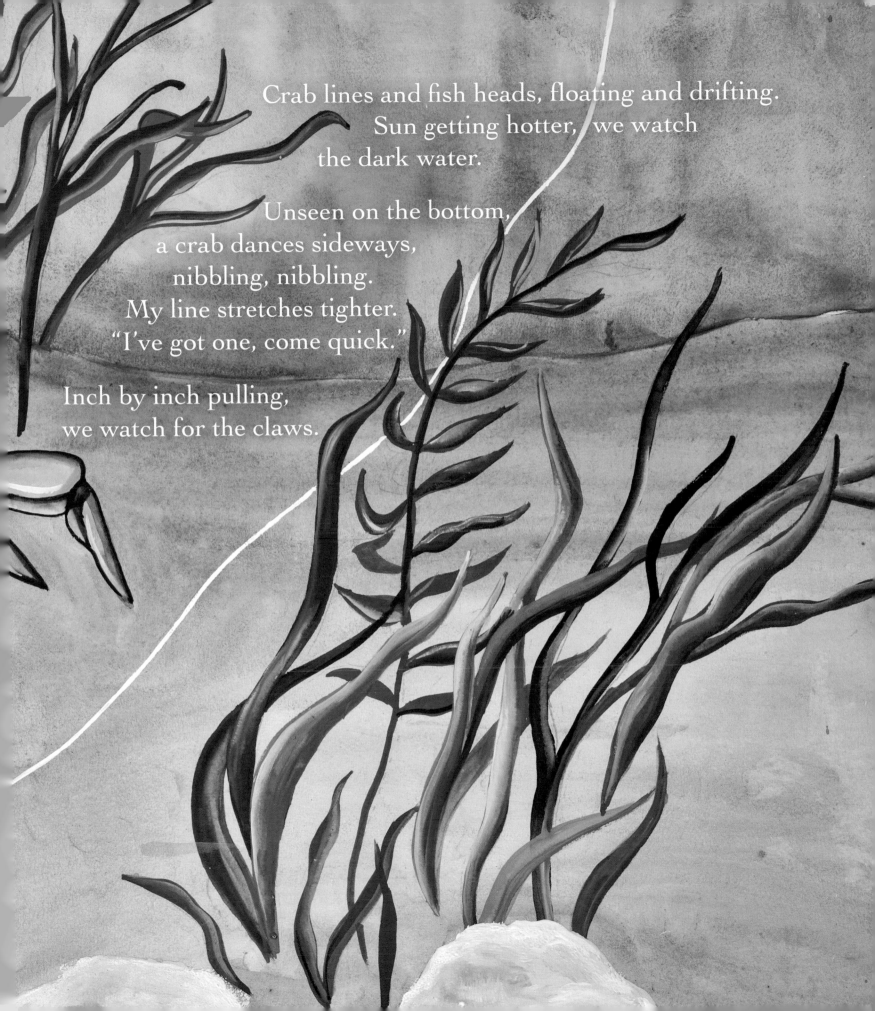

Crab lines and fish heads, floating and drifting.
Sun getting hotter, we watch
the dark water.

Unseen on the bottom,
a crab dances sideways,
nibbling, nibbling.
My line stretches tighter.
"I've got one, come quick."

Inch by inch pulling,
we watch for the claws.

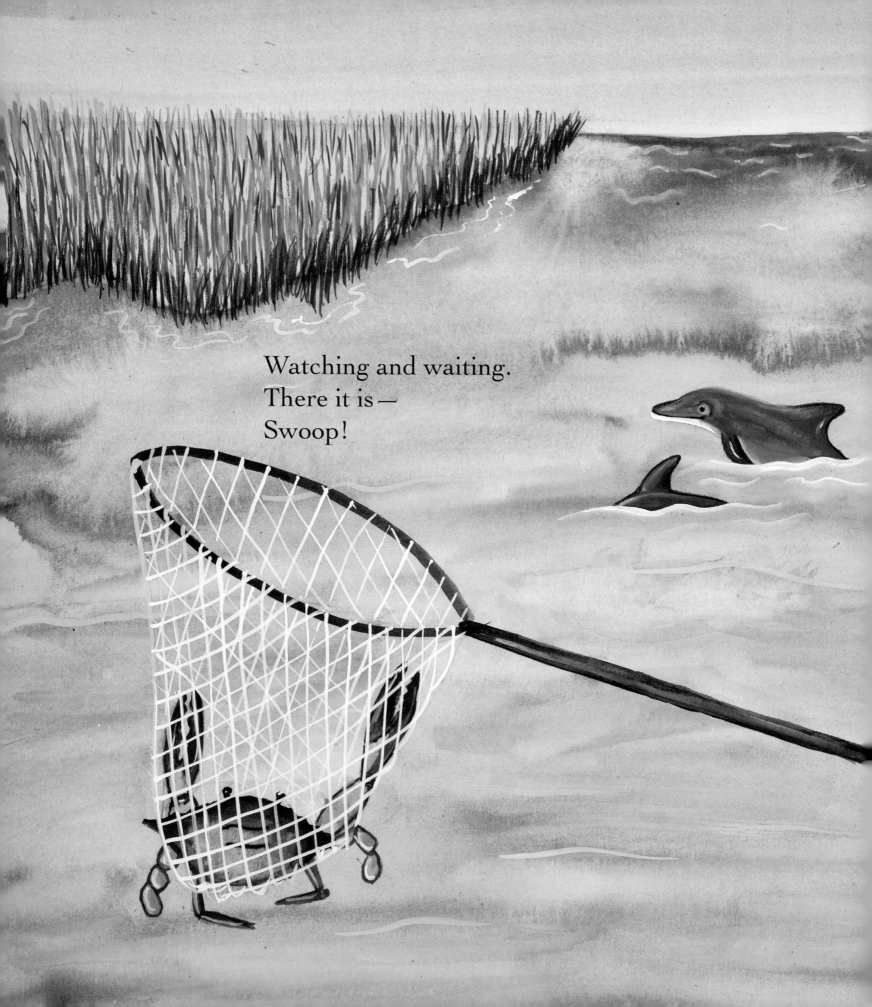

Watching and waiting.
There it is —
Swoop!

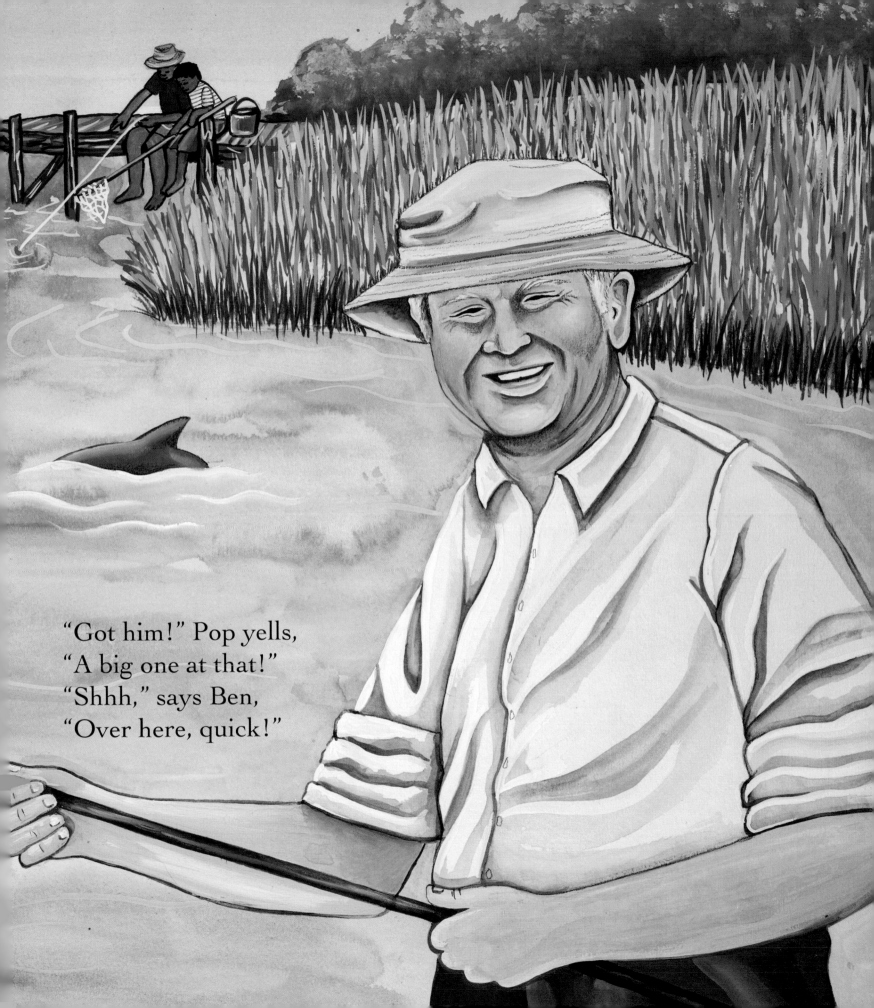

"Got him!" Pop yells,
"A big one at that!"
"Shhh," says Ben,
"Over here, quick!"

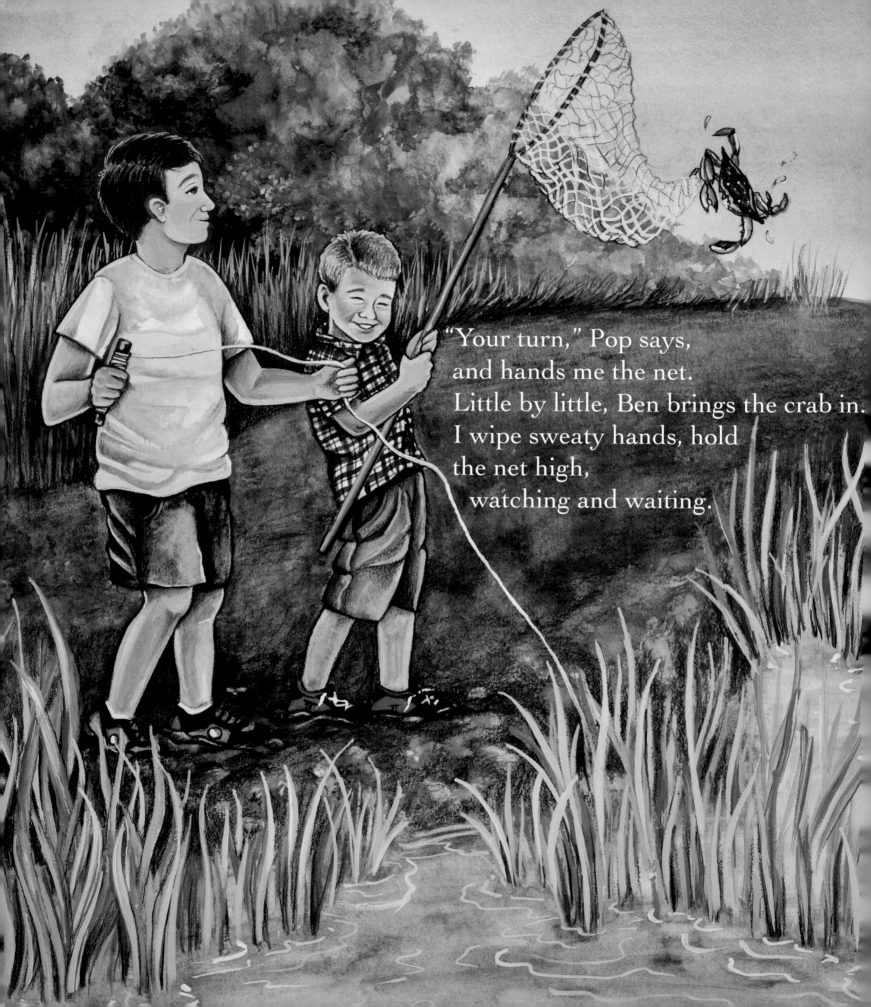

"Your turn," Pop says,
and hands me the net.
Little by little, Ben brings the crab in.
I wipe sweaty hands, hold
the net high,
watching and waiting.

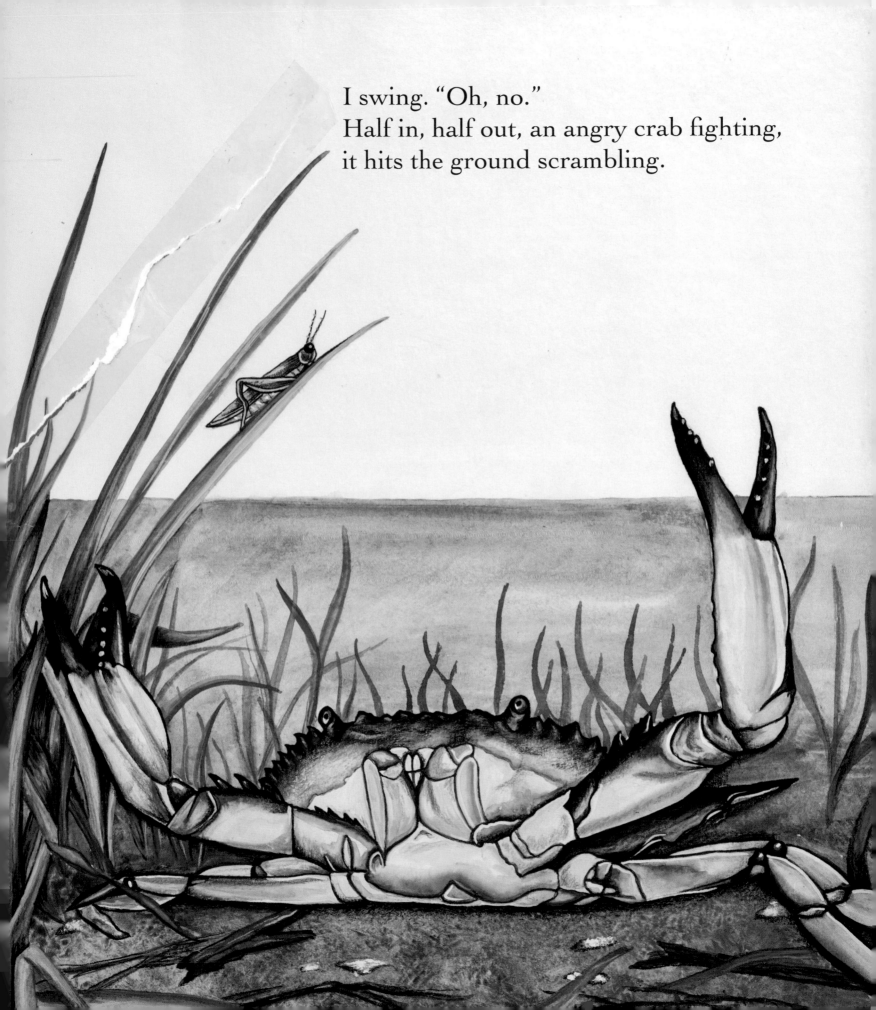

I swing. "Oh, no."
Half in, half out, an angry crab fighting,
it hits the ground scrambling.

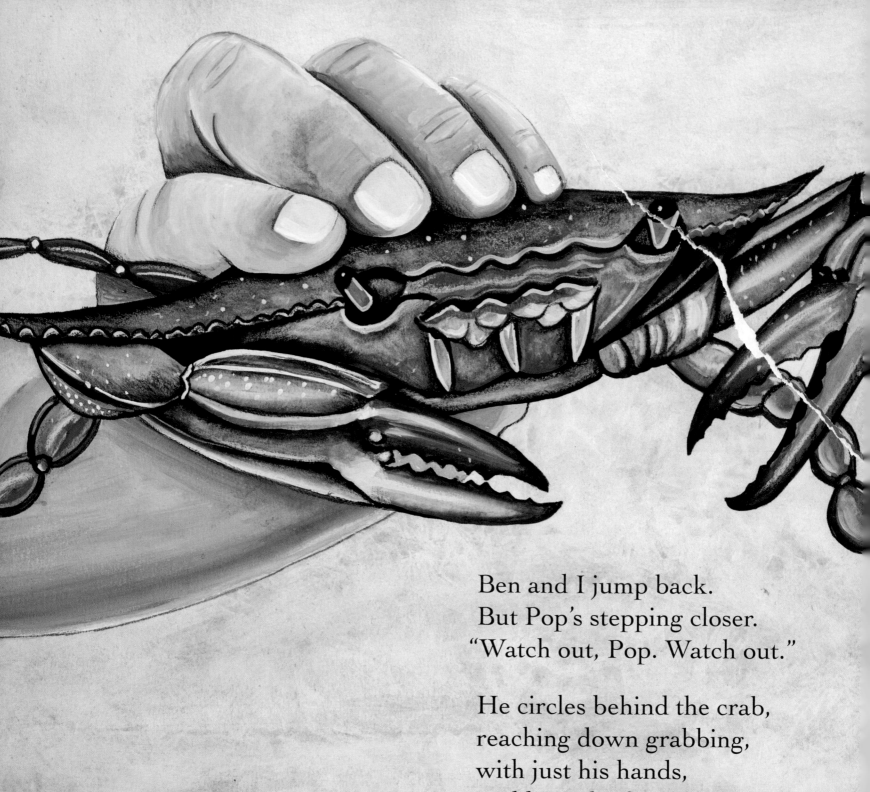

Ben and I jump back.
But Pop's stepping closer.
"Watch out, Pop. Watch out."

He circles behind the crab,
reaching down grabbing,
with just his hands,
grabbing the fearsome crab.

He holds it out toward us,
its claws clicking and clacking.

We back up some more.

"Whoops," says Pop, pretending to drop it.
We laugh as it goes in the bucket.

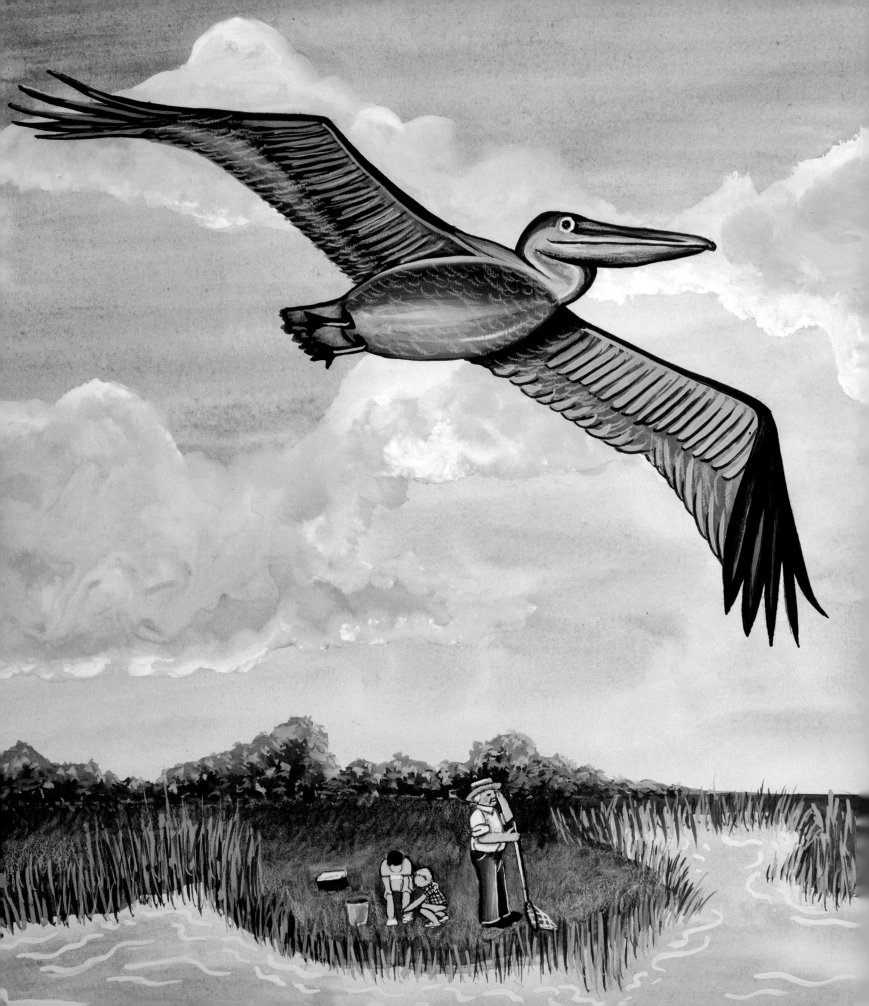

All afternoon with the tide coming in,
we're checking our lines,
waiting for crabs and scooping them up.
Some are with eggs, and some are too small,
but some are worth keeping.
We call them Big Blues.

The tide's rushing out,
a light breeze now blowing.
Pop looks at the sky, "Okay, boys, cut bait."

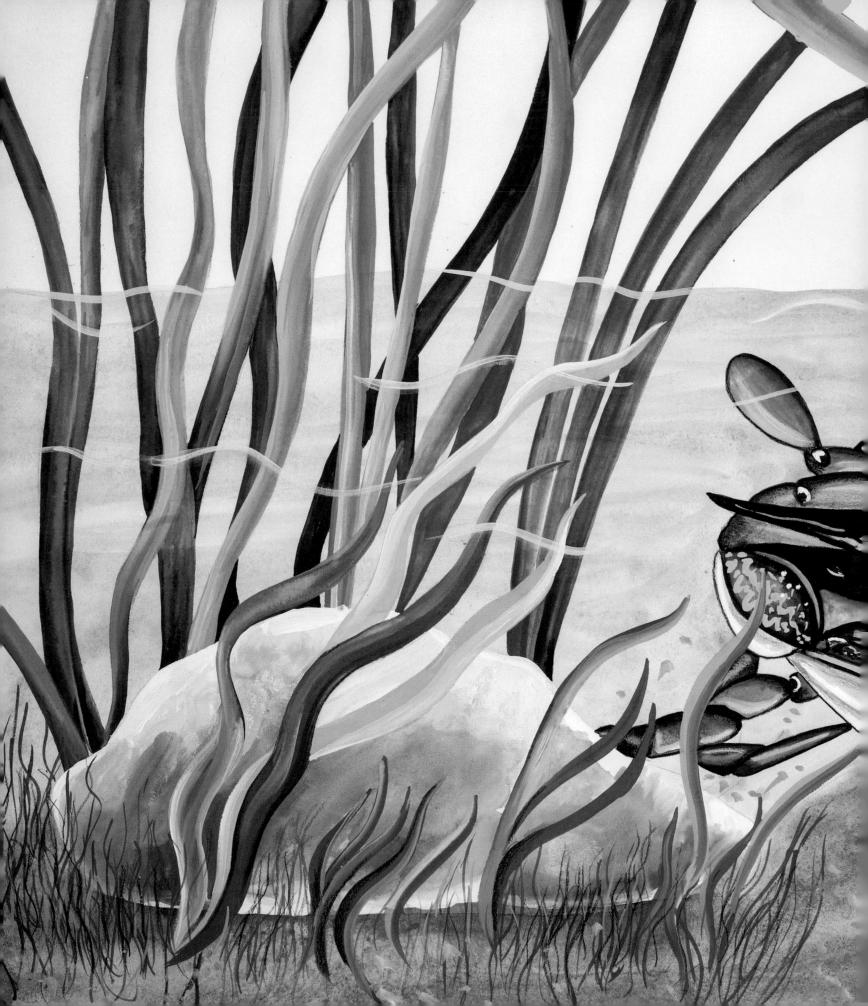

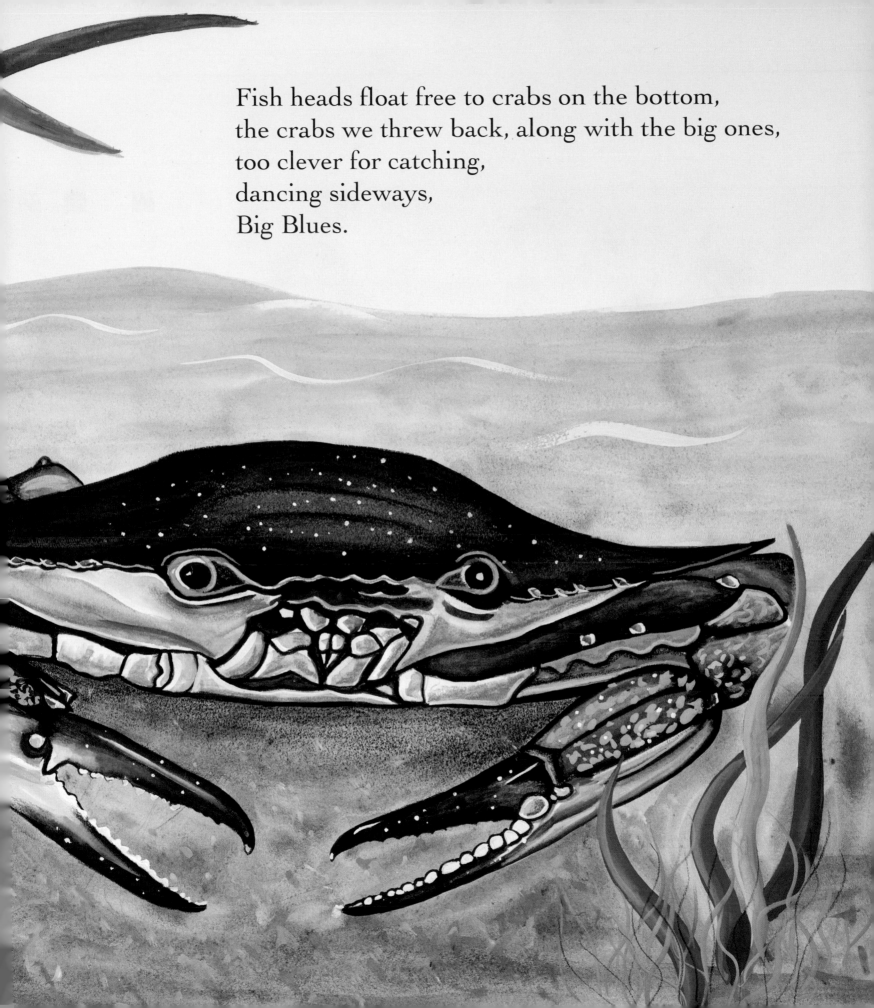

Fish heads float free to crabs on the bottom,
the crabs we threw back, along with the big ones,
too clever for catching,
dancing sideways,
Big Blues.

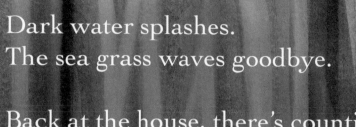

Dark water splashes.
The sea grass waves goodbye.

Back at the house, there's counting for bragging,
there's cooking, there's cracking and picking the shells,
there's mixing and fixing and in the pan sizzling,
and then there's good eating.

"Mmmmmm. Crab cakes."

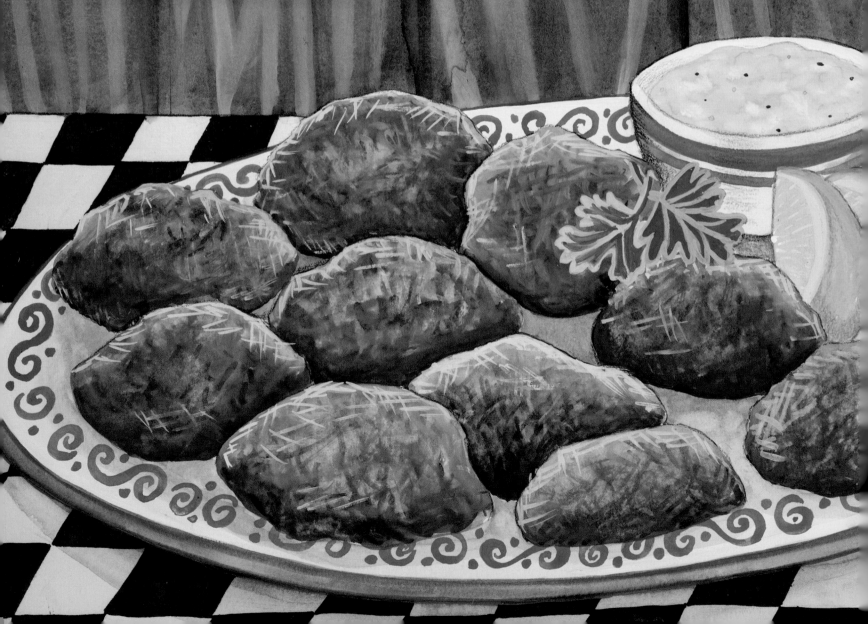

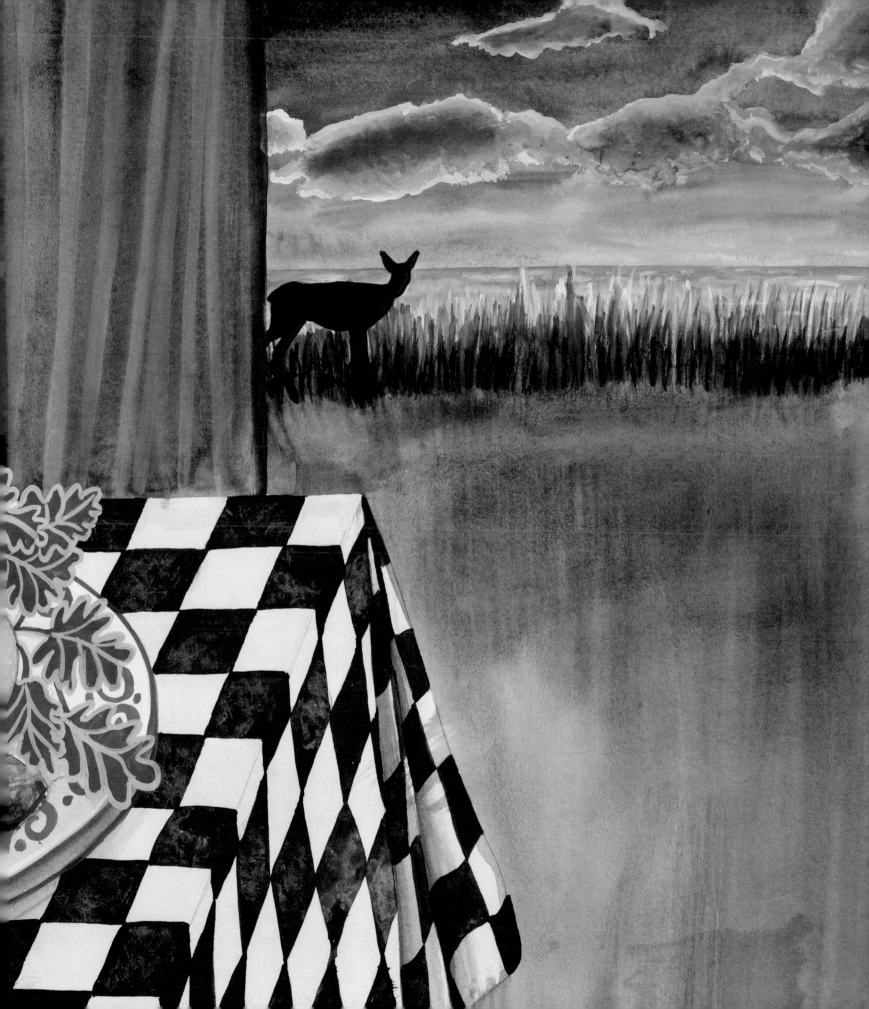

About Blue Crabs *(Callinectes sapidus)*

The blue crab is named for its sapphire blue front legs. Its two back legs are paddles for swimming. It walks sideways across the sand with the other six legs. The blue crab is beautiful to watch and delicious to eat. But be careful around a blue crab! Its front legs have dangerous pincers!

Jimmies and Sooks

How can you tell a female crab from a male? Her claws have bright orange tips, like painted fingernails! Turn a crab over and look at the belly. The male (Jimmy) has a T-shaped apron. The young female (she-crab) has a diamond-shaped apron. The older female (sook) has a rounded apron. Females with eggs are sometimes called "sponge crabs" because the eggs look like an orange sponge attached to the outside of the apron.

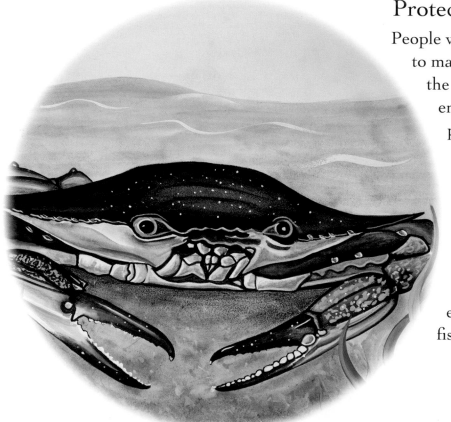

Protecting the Future

People who love to catch and eat blue crabs want to make sure the ocean stays full of them. Like the family in this story, some people catch just enough crabs for their own eating. Other people sell the crabs they catch. They use crab traps to catch them quickly and easily. State laws are made to protect crabs and their habitats. You can help too. If a crab's shell is less than 5 inches across, throw it back into the water. Female crabs should also be thrown back. Each female may lay up to 8 million eggs. One of those eggs may grow into a crab to nibble your fish head.

About Other Plants and Animals You've Seen in *Crabbing*

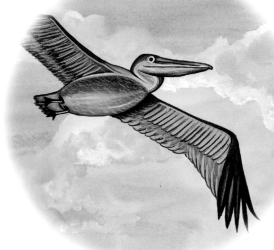

Brown Pelican With a wingspan of over 6 feet, brown pelicans skim and dive-bomb the ocean and marshes in search of schools of fish for a tasty meal.

Cordgrass
Cordgrass grows in the marsh waters and is a food source and home to many marsh creatures.

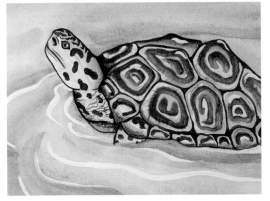

Diamond-back Terrapin The diamond-back terrapin gets its name from the wonderful shapes on its shell. It is a small saltwater turtle that makes its home in tideland marshes and lagoons.

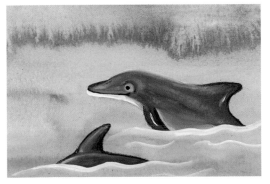

Dolphins Dolphins are marine mammals that breathe in air through blowholes, but also use these holes to send out high-pitched squeaks for undersea communication with one another. A group of dolphins is called a pod and may hunt together for squid, fish, and crabs.

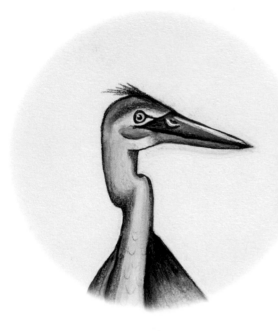

Great Blue Heron Great blue herons stand 4 feet tall and are immediately recognizable by their slate-blue feathers. Stepping quietly through the marsh on their long legs, herons hunt a variety of small marine animals.

Live Oak Hardy and resistant to salt water, live oaks are plentiful along the coast. Their long branches are often covered in Spanish moss.

Spanish Moss Neither Spanish nor moss, the plant called Spanish moss is really a rootless air plant that makes its home hanging from trees where it can absorb sunlight and rainwater.

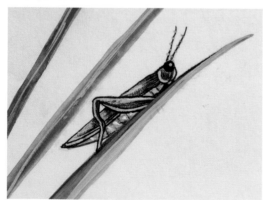

Toothpick Grasshopper Grasshoppers feed on the grassy stems of marsh plants.

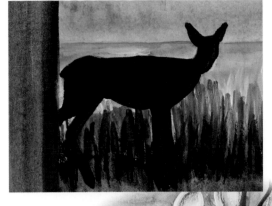

White-tailed Deer Often seen at dusk, white-tailed deer eat a variety of plants and nuts found in coastal forests, including acorns, ferns, and mushrooms. When startled, deer can run from danger at speeds of nearly 30 miles per hour!

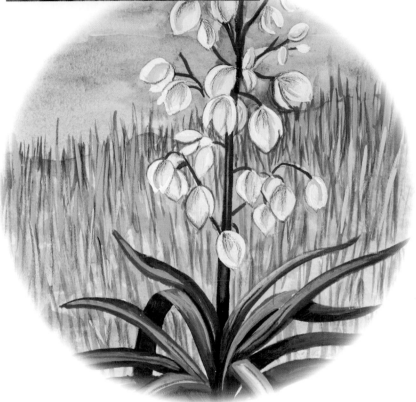

Yucca A group of shrubs and trees in the lily family, yuccas flourish in the coastal dunes. They can grow to heights of 10 to 12 feet.

For more information about coastal plants and animals, please see Todd Ballantine's *Tideland Treasure: The Naturalist's Guide to the Beaches and Salt Marshes of Hilton Head Island and the Atlantic Coast*, 2nd ed. (Columbia, S.C.: University of South Carolina Press, 2013), which was consulted in creating the illustrations for this book.

Crab Cakes

(Makes about 6 crab cakes)

Ingredients

1 pound of crab meat (about 2 cups)
1 jumbo egg (beaten with a fork)
½ cup of mayonnaise
1 teaspoon of seafood seasoning (if you like)
¼ teaspoon lemon juice (if you like)

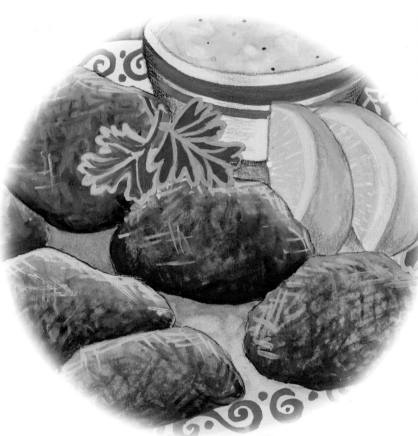

Steps

Mix everything in a bowl.

Use cooking spray or a little olive oil on the bottom of a frying pan to keep the crab cakes from sticking.

Put the pan on the eye of the stove at medium to hot heat.

Using a big cooking spoon, drop six spoonsful of crab mixture in the pan.

Flatten them a little and push the sides in to make them the shape you want. (Do this as soon as they are in the pan.)

Let them cook at least 10 minutes on the first side.

When they hold together well enough, flip them, and cook another 10 minutes.

When both sides are brown, they are ready to eat.